Vintage Tattoo Designs

Coloring Book for Adults

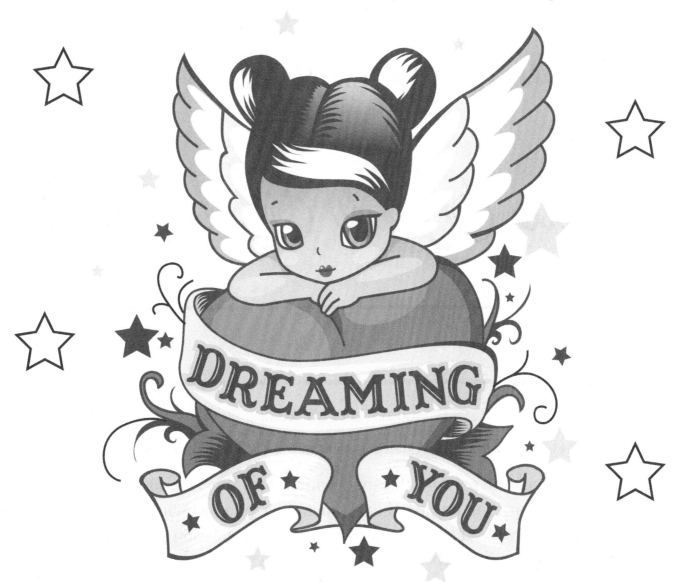

DREAMING OF YOU

Vintage Tattoo Designs

vintage
TATTOO

Coloring Book for Adults

This Book Belongs to

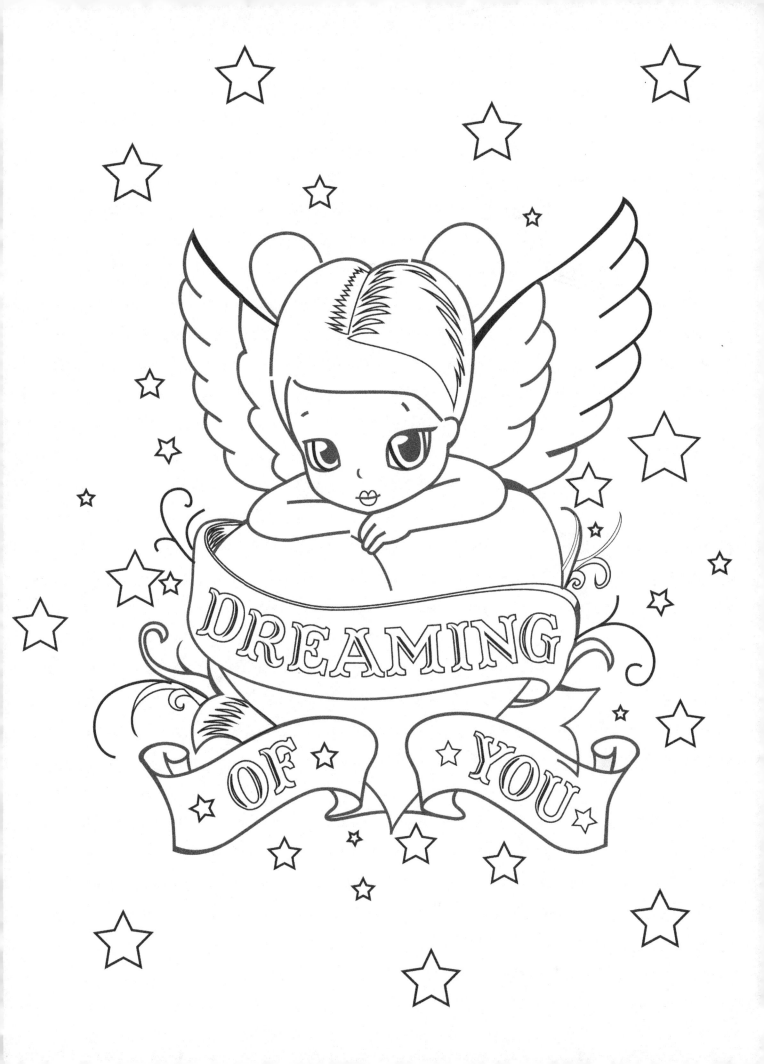

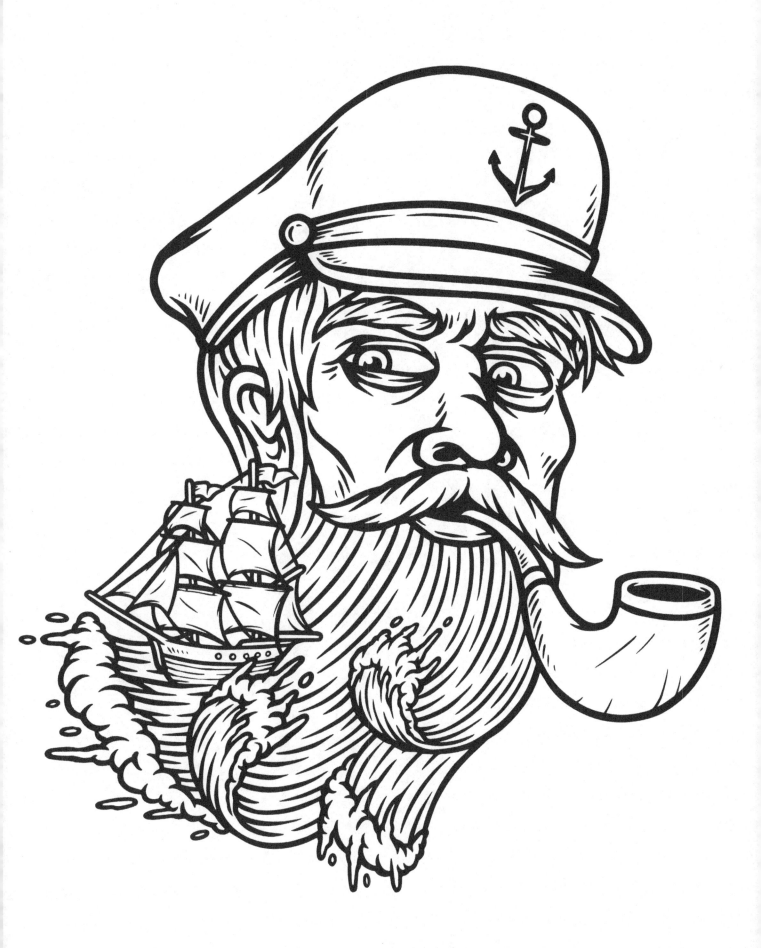

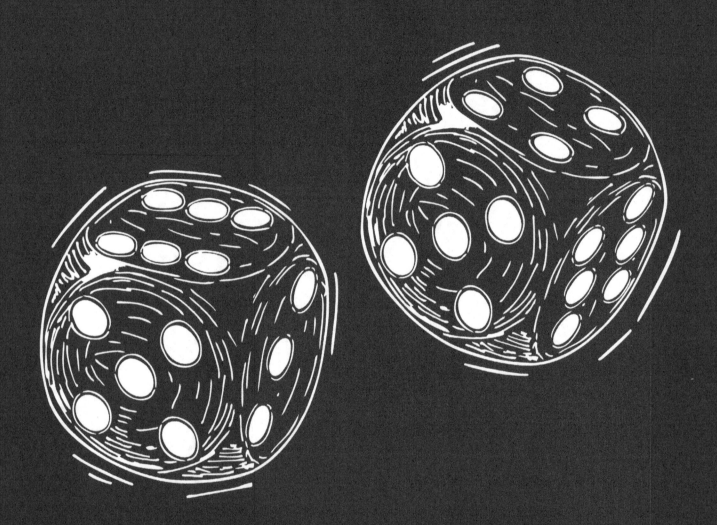

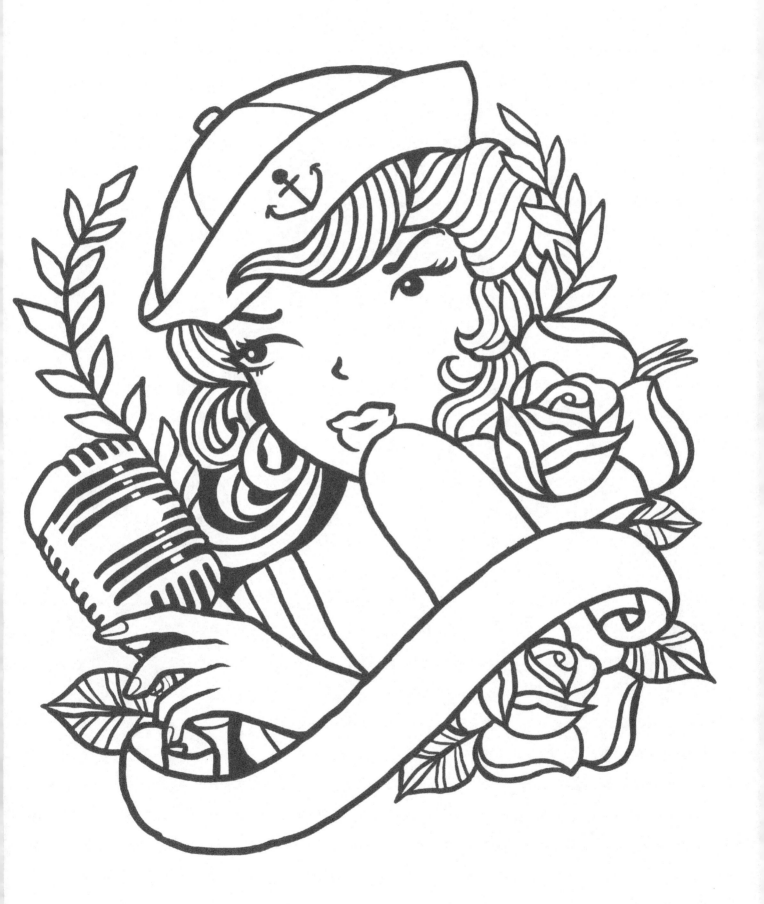

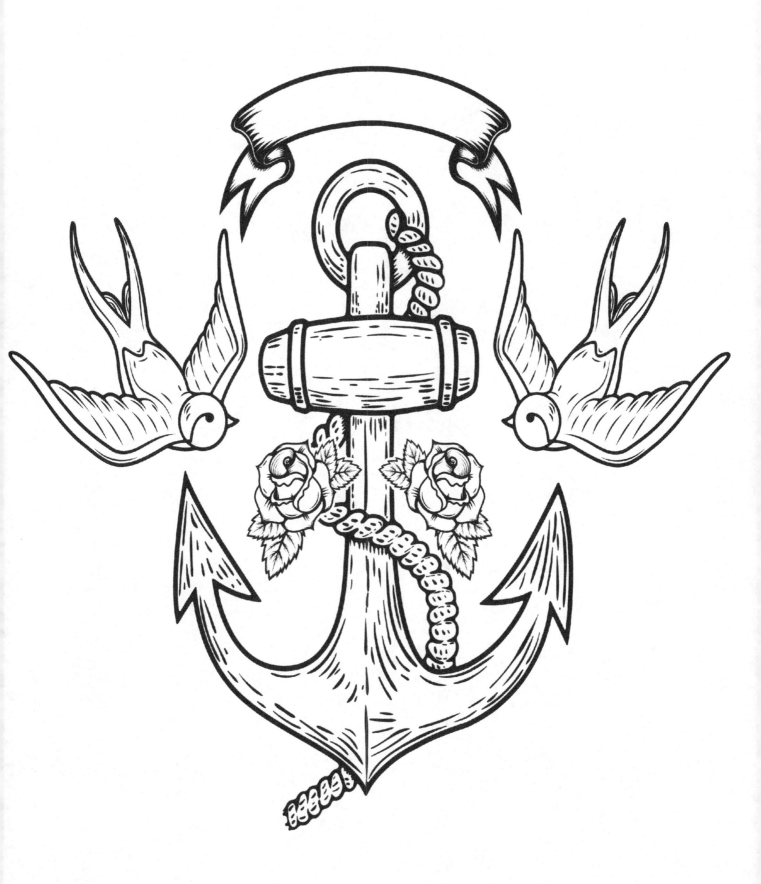

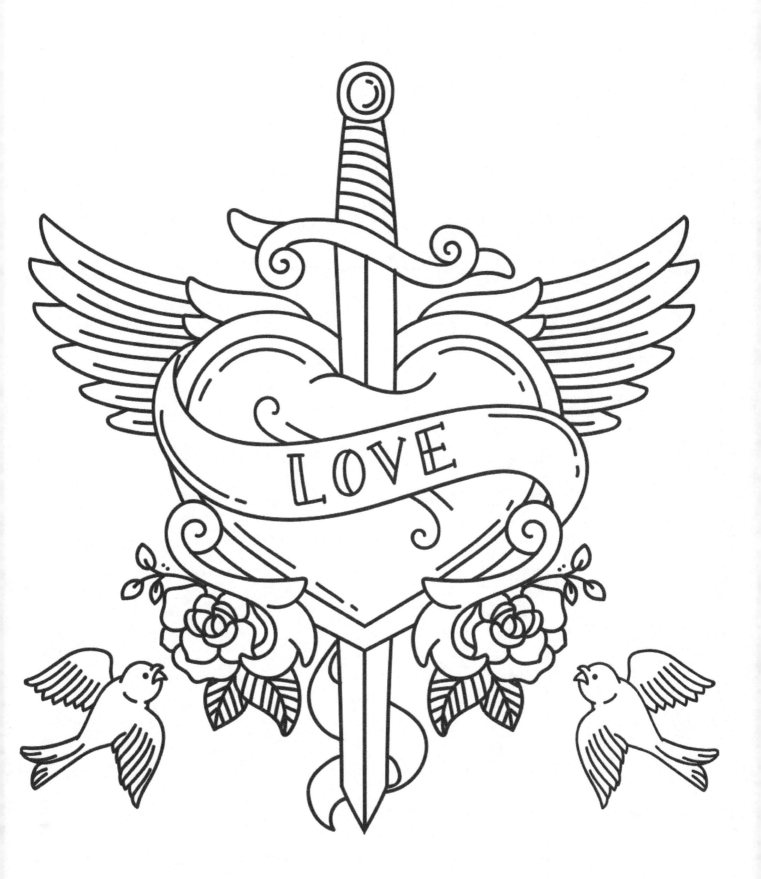

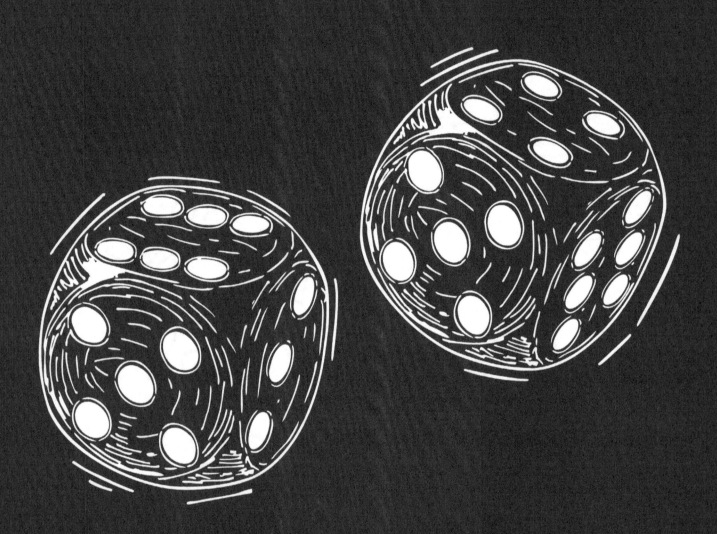

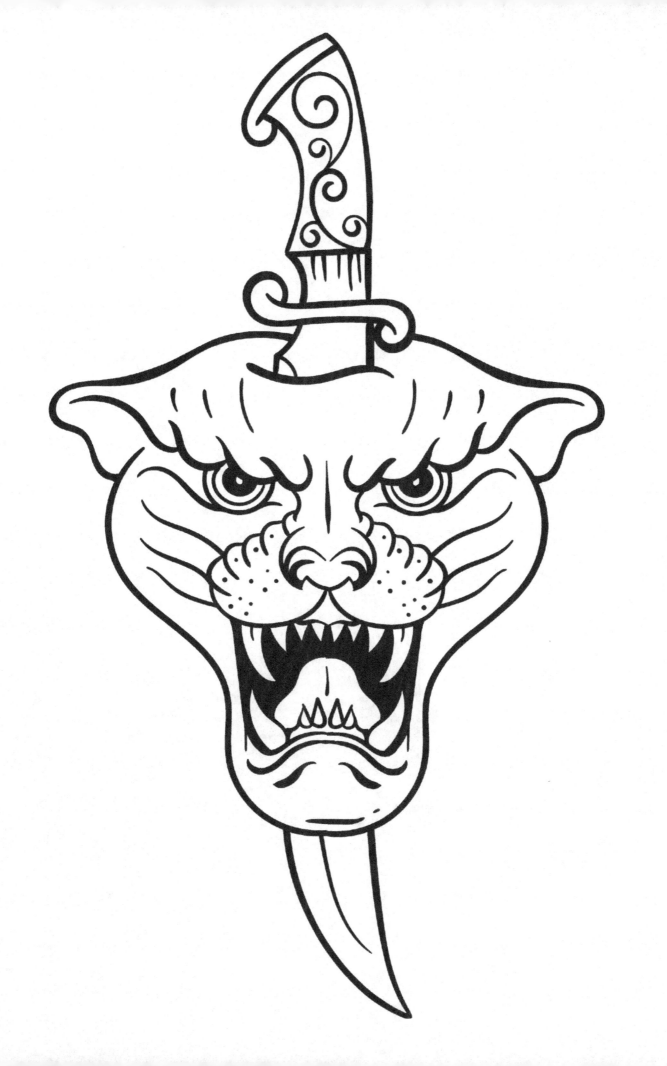

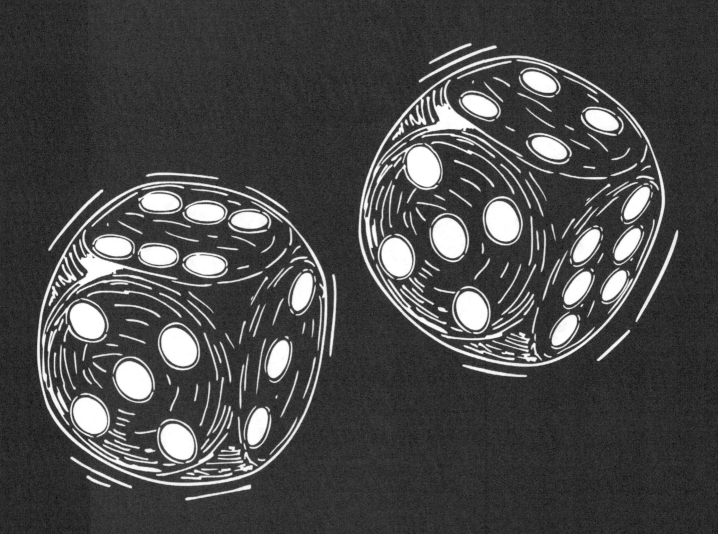

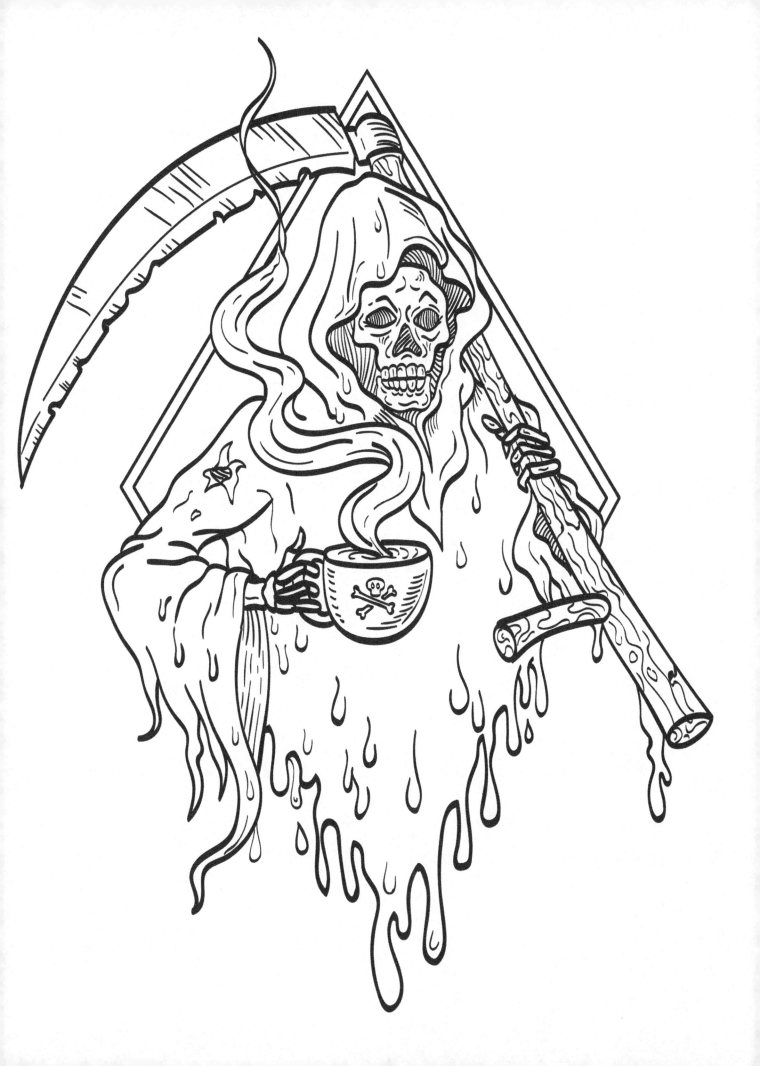

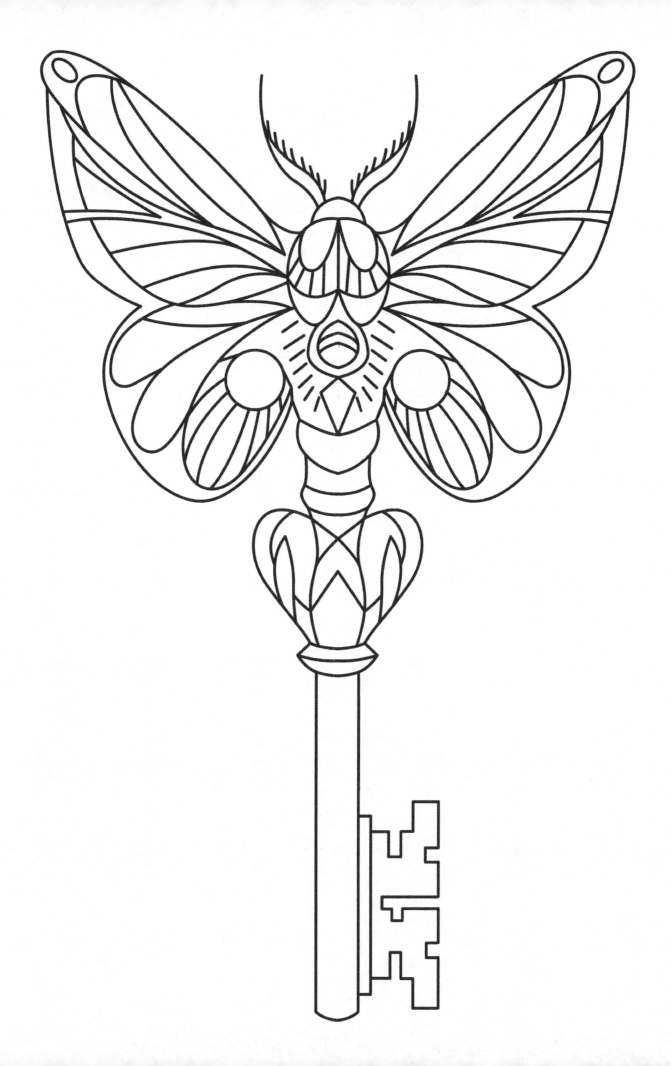

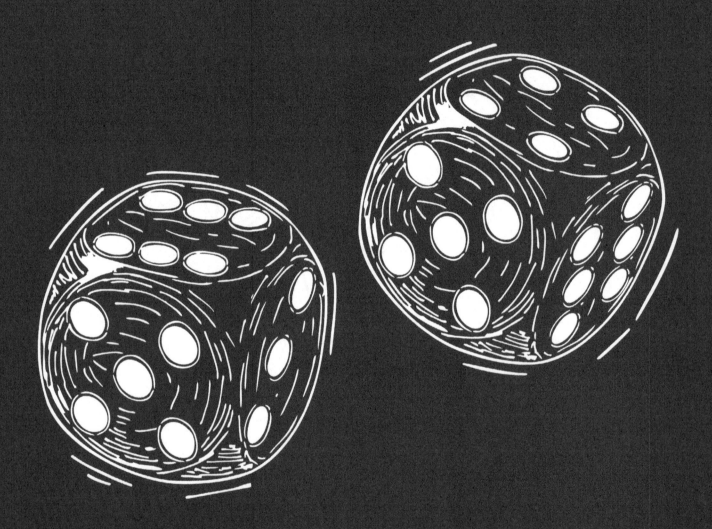

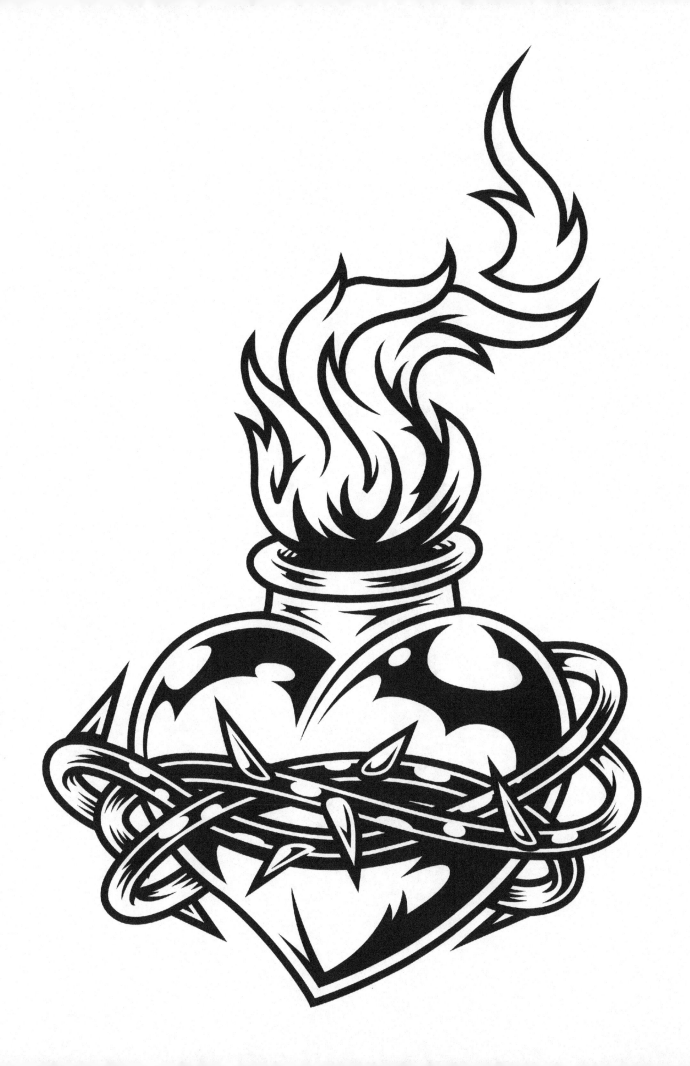

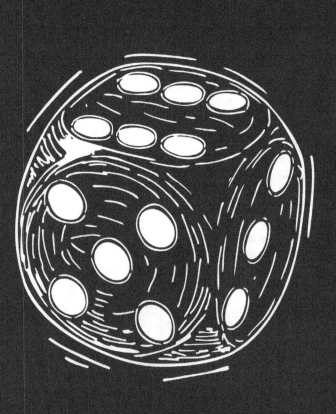

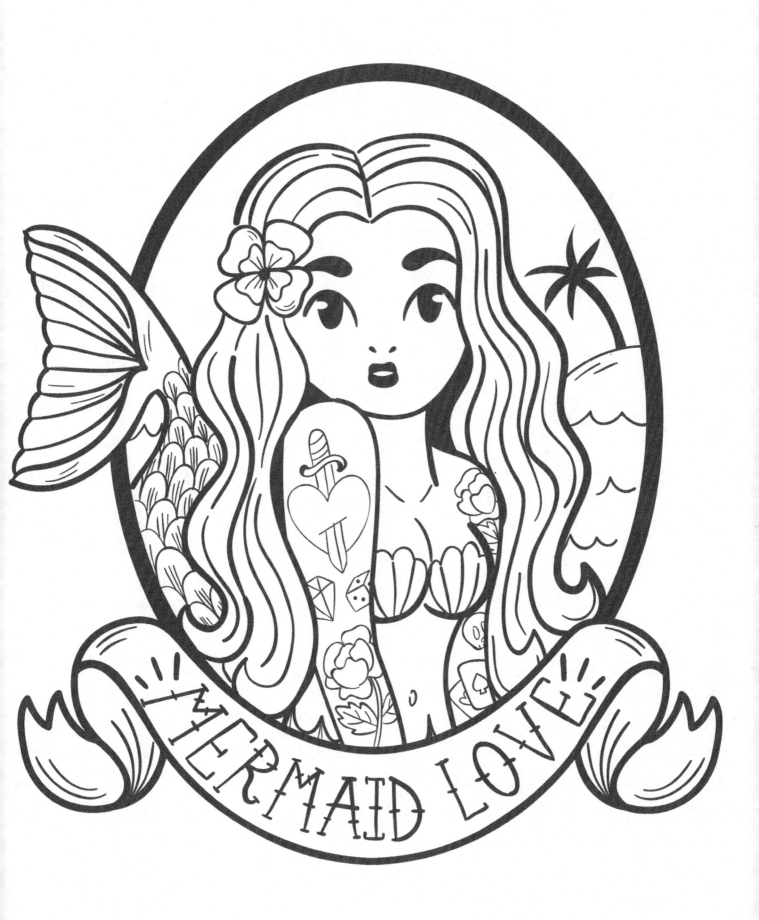

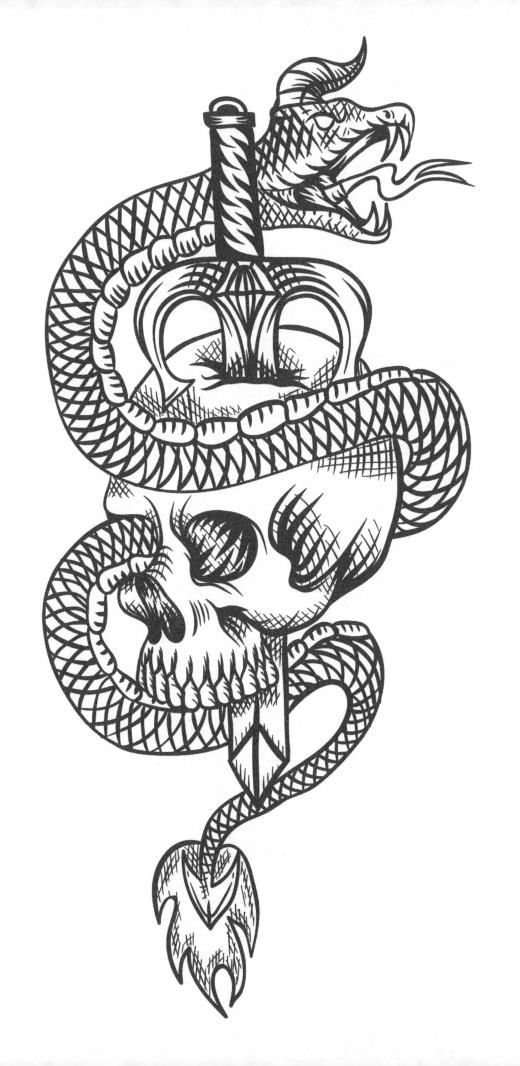

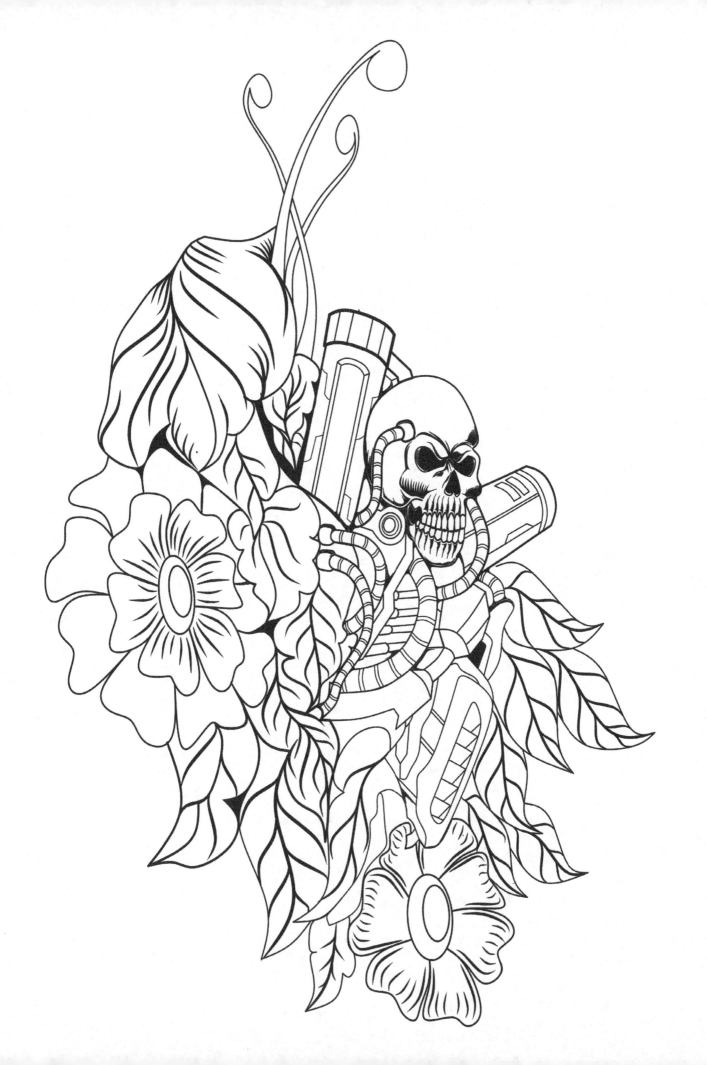

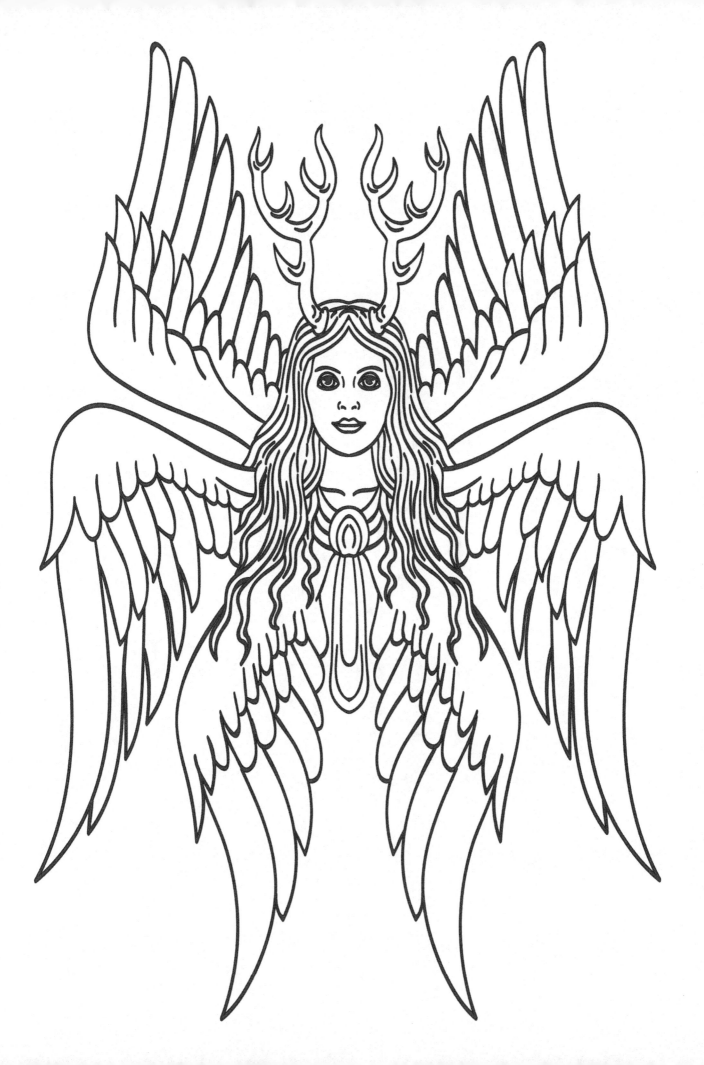

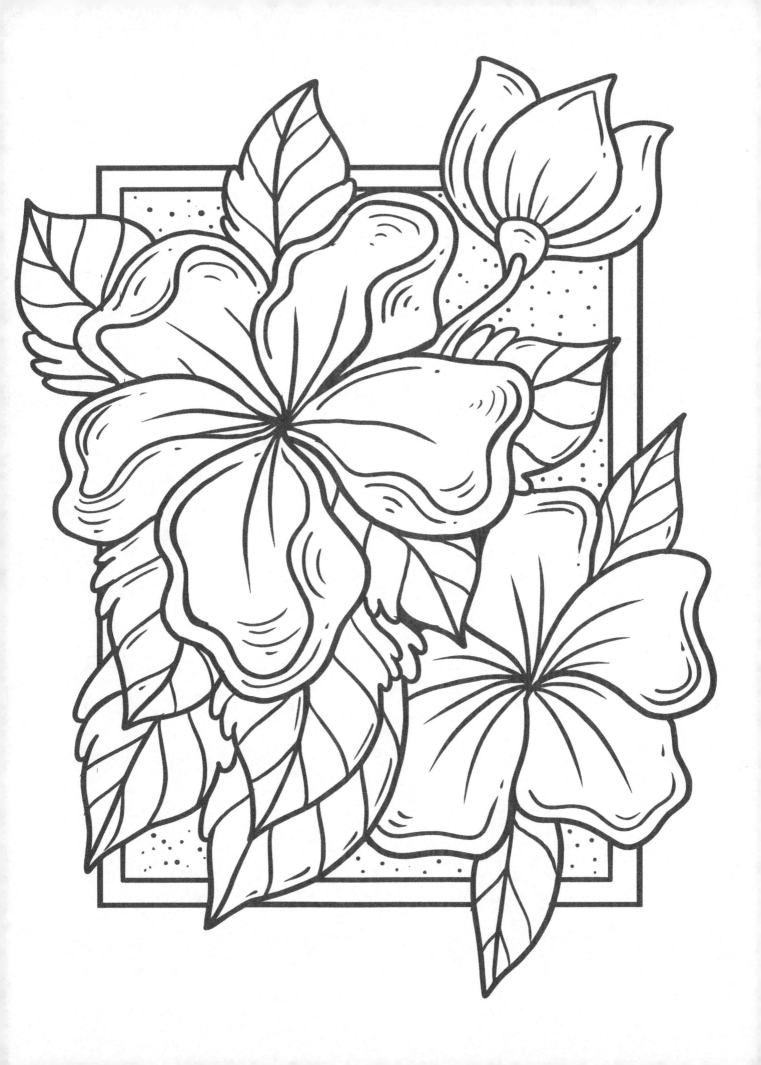

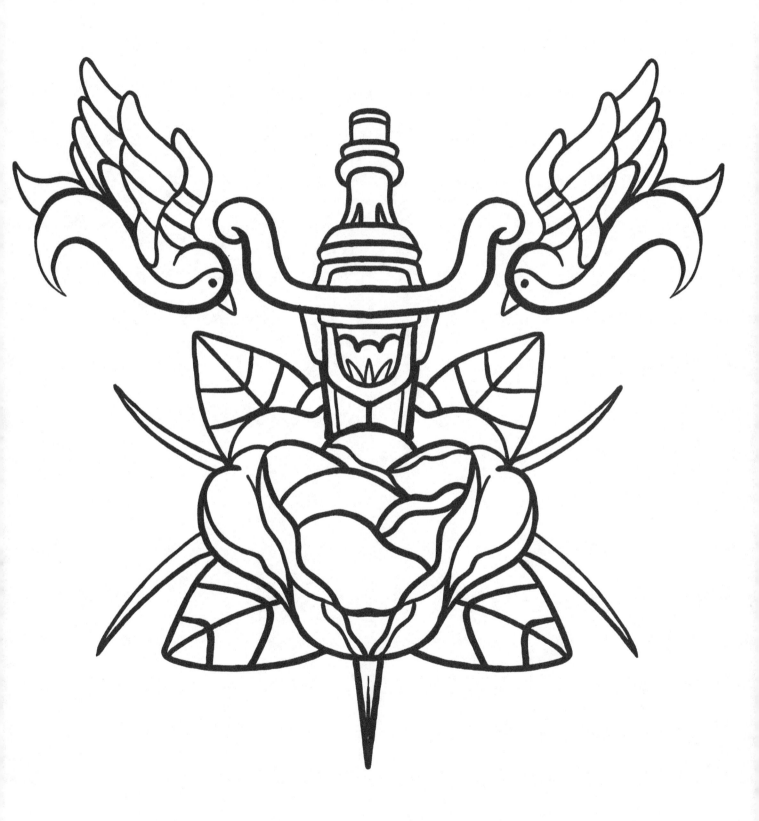

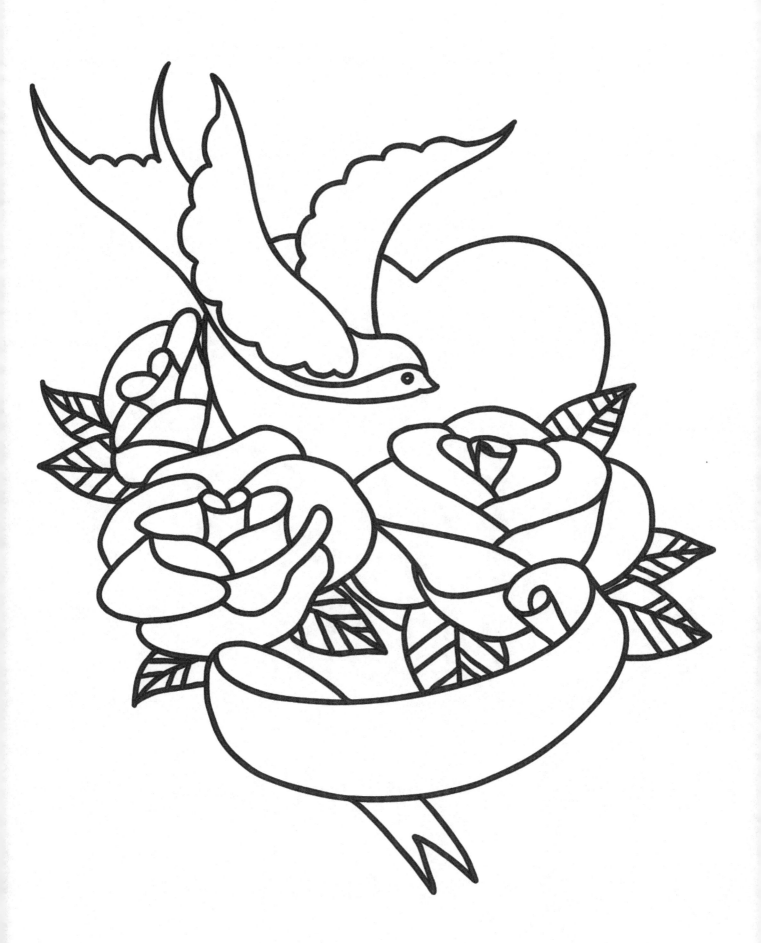

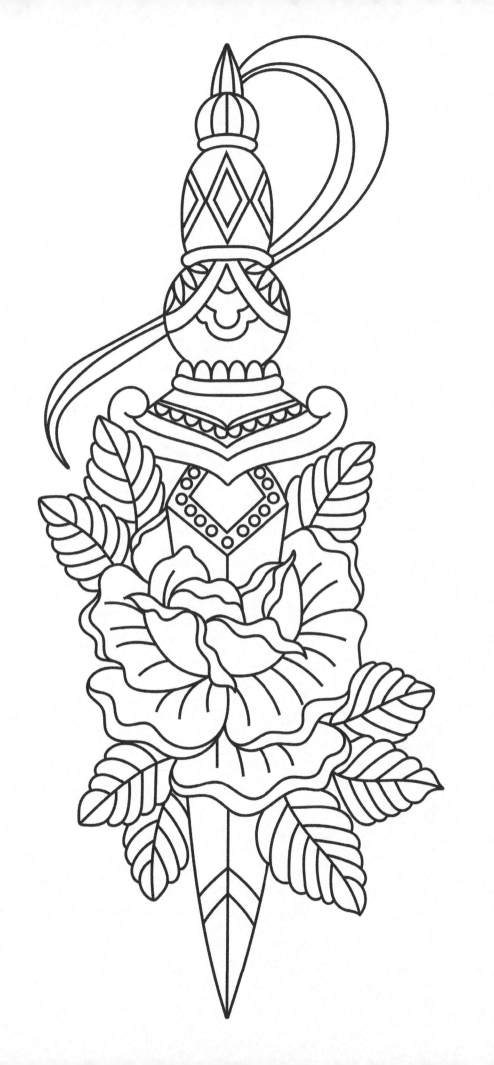

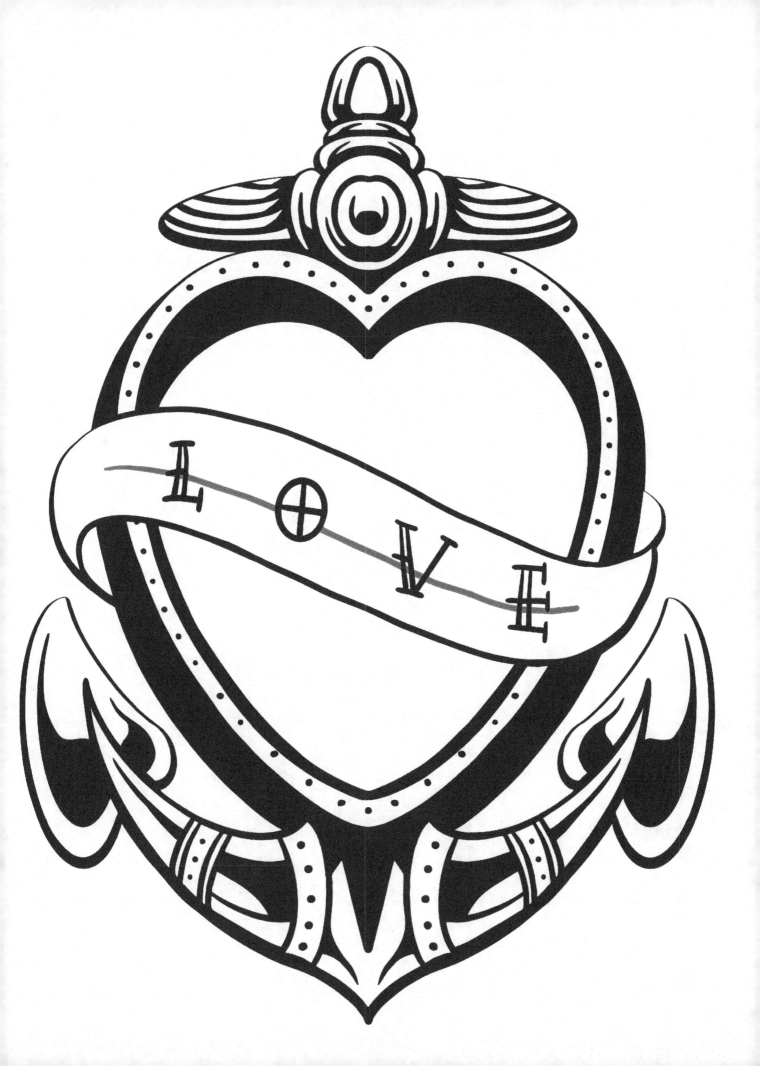

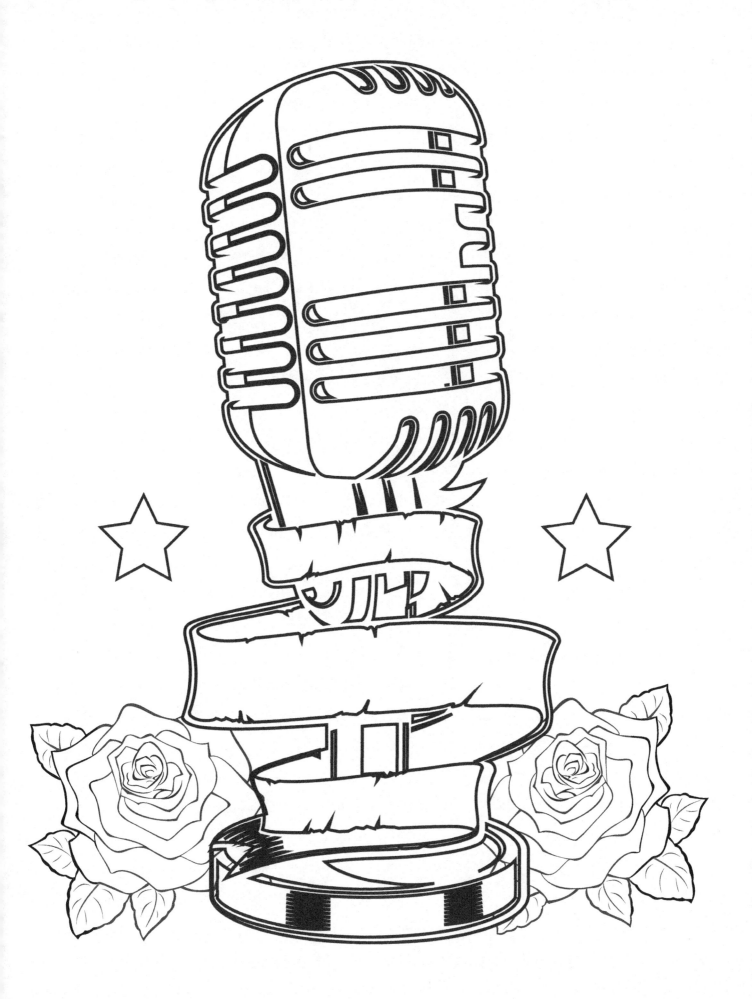

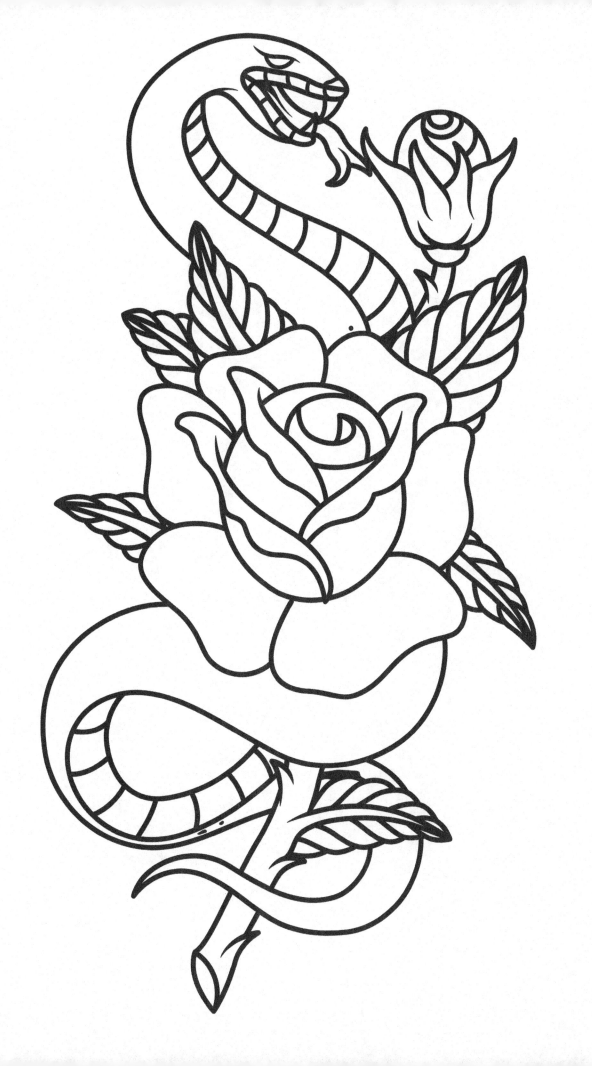

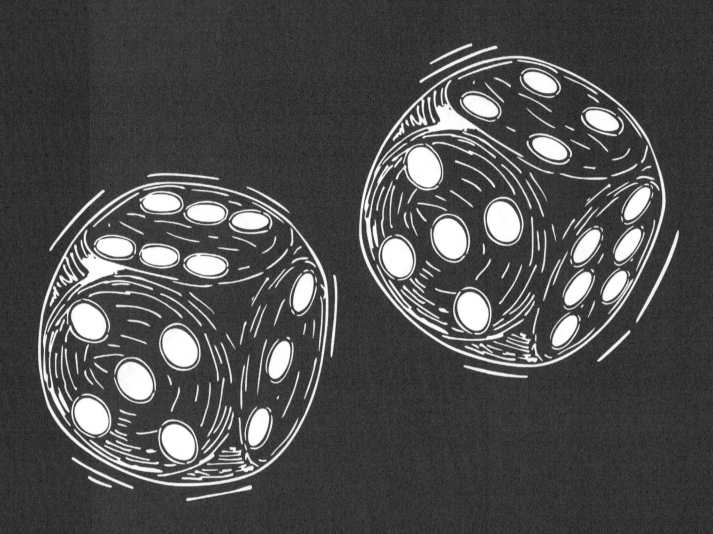

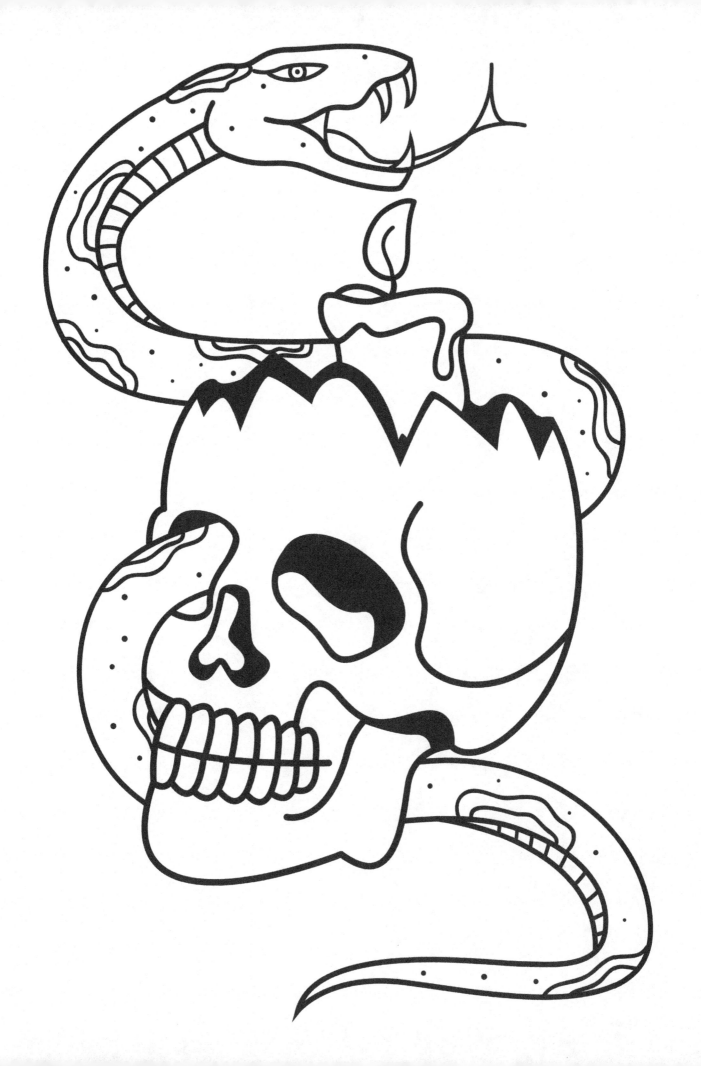

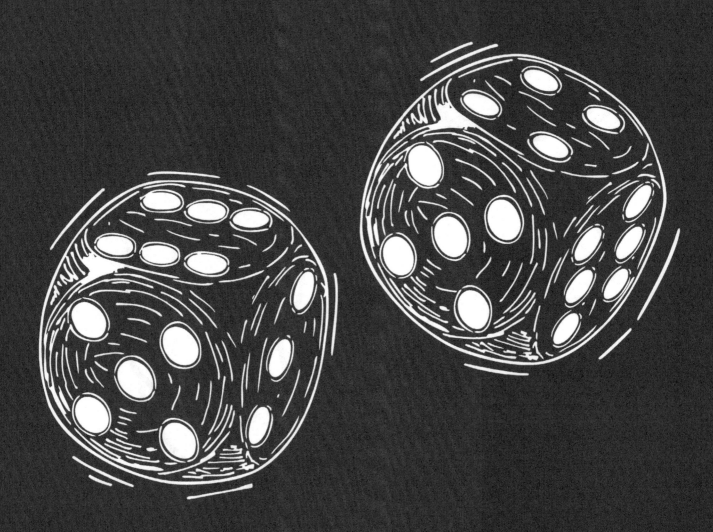

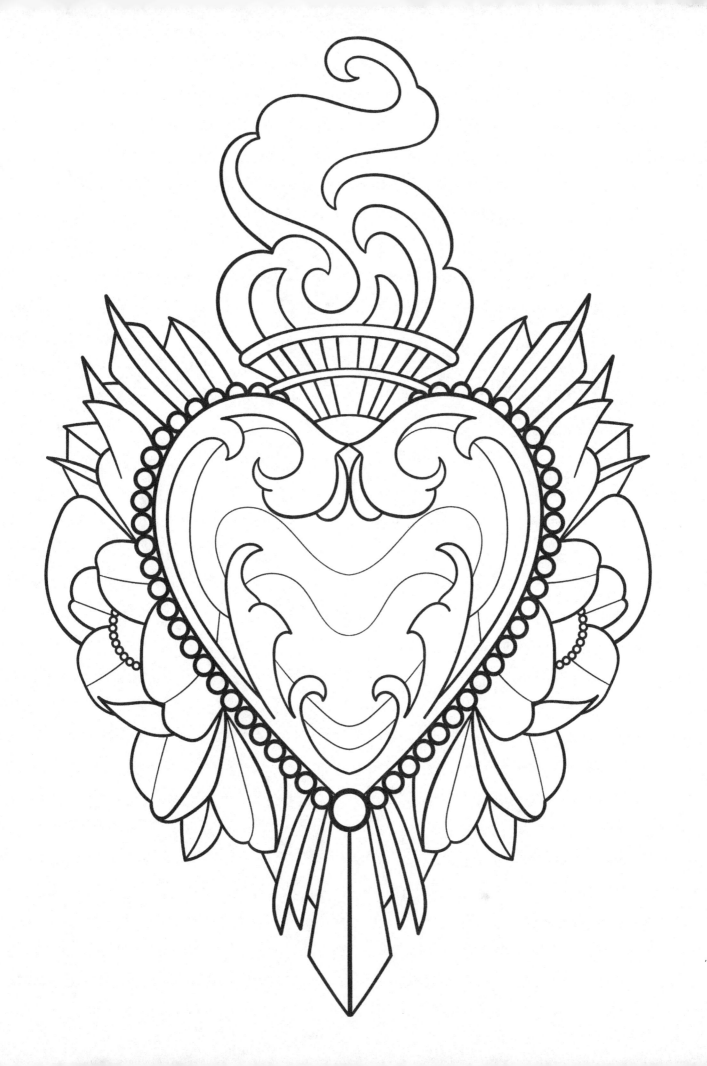

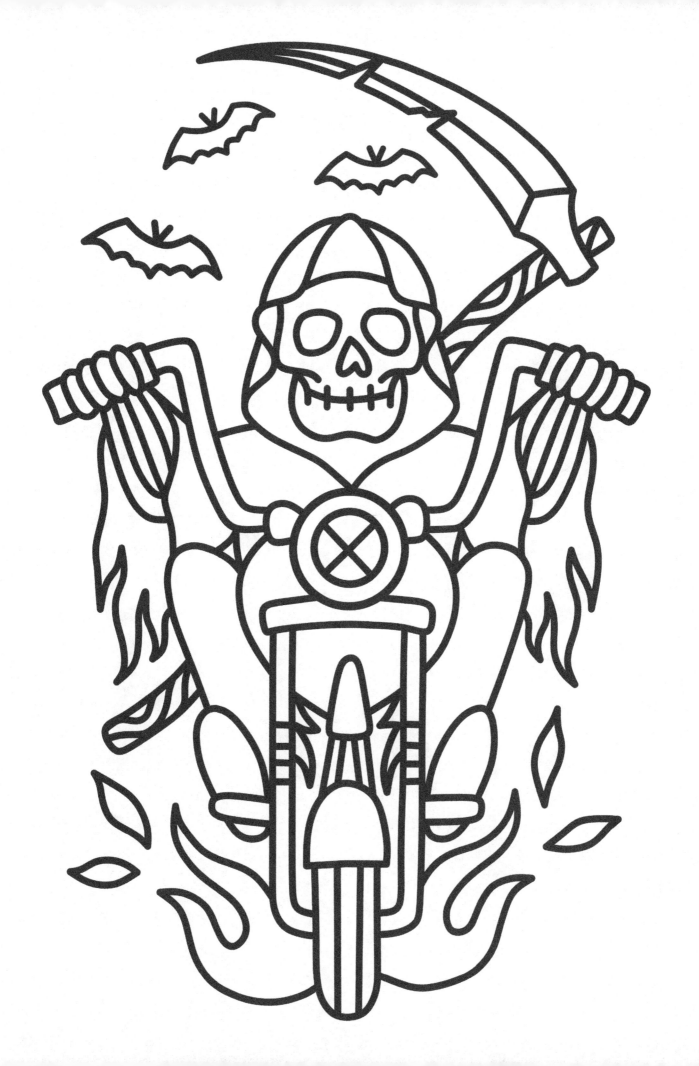

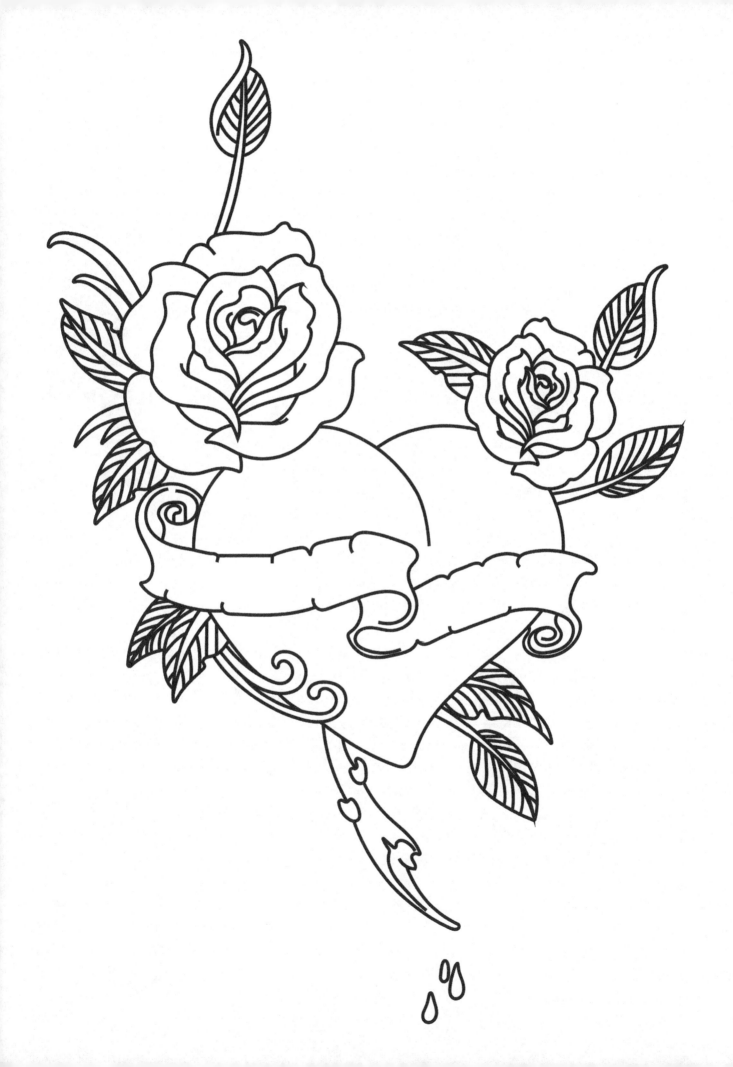

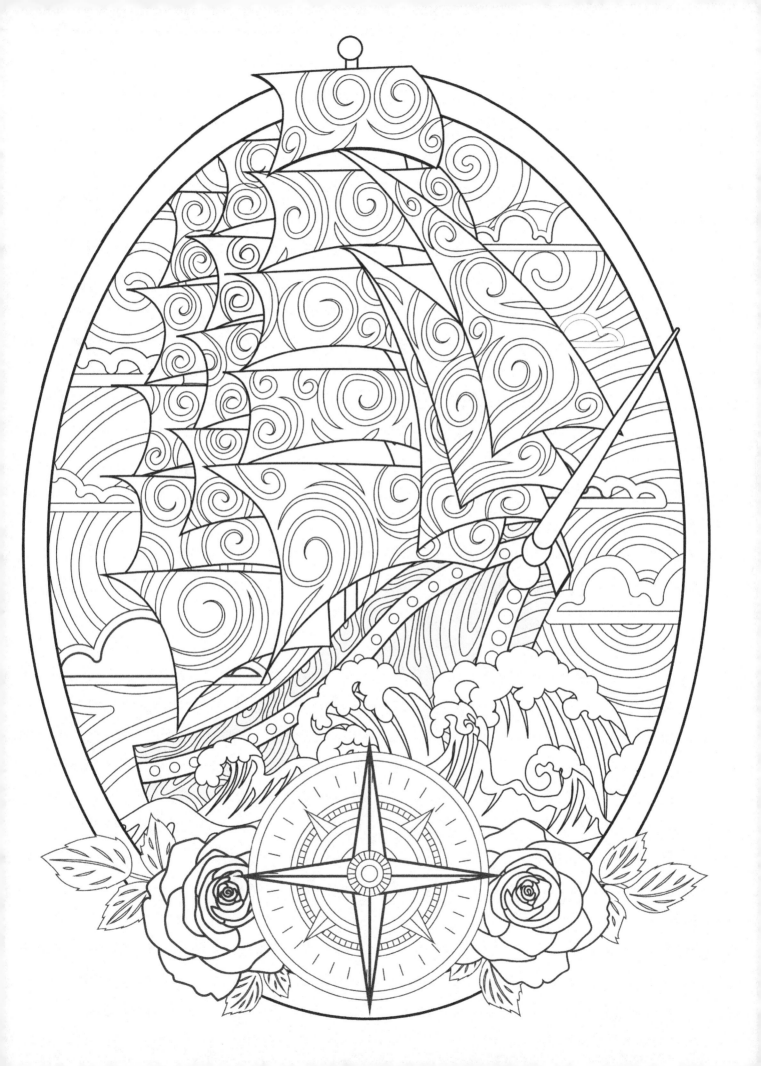

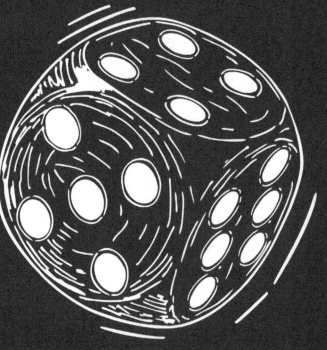
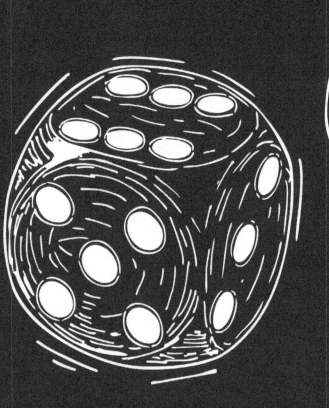

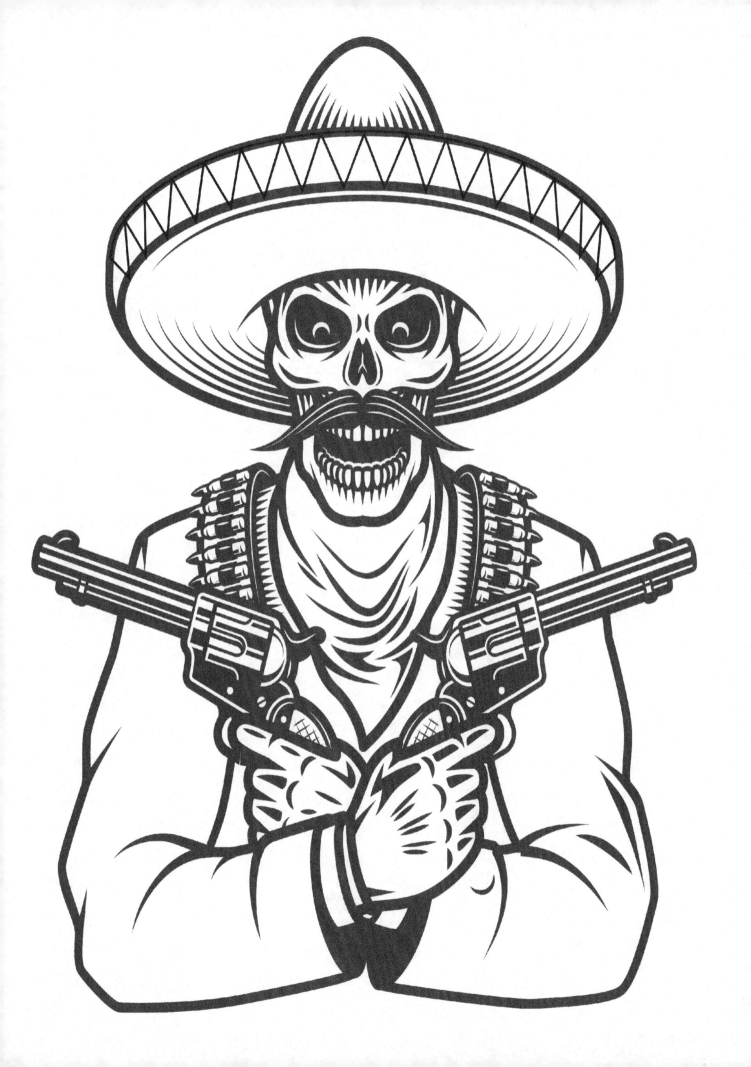

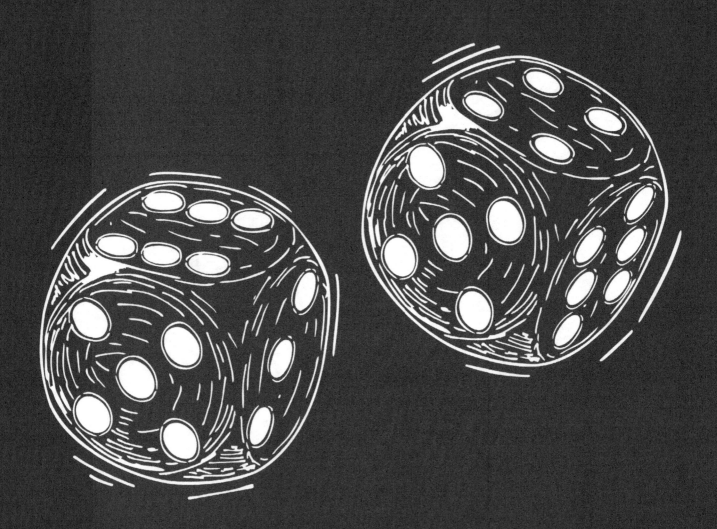

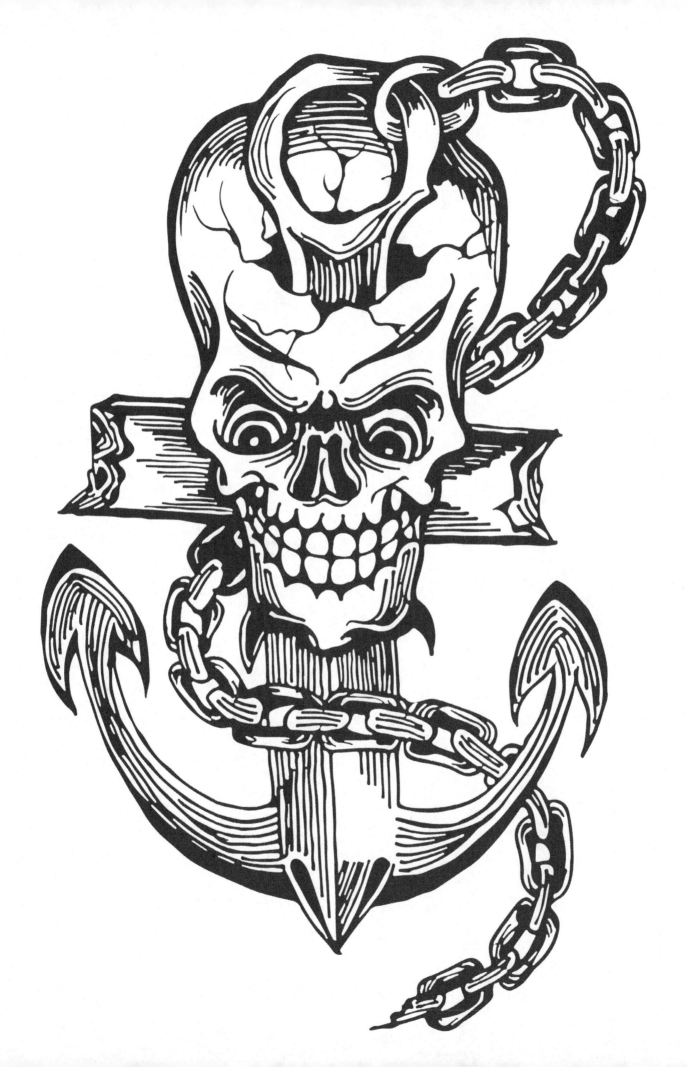

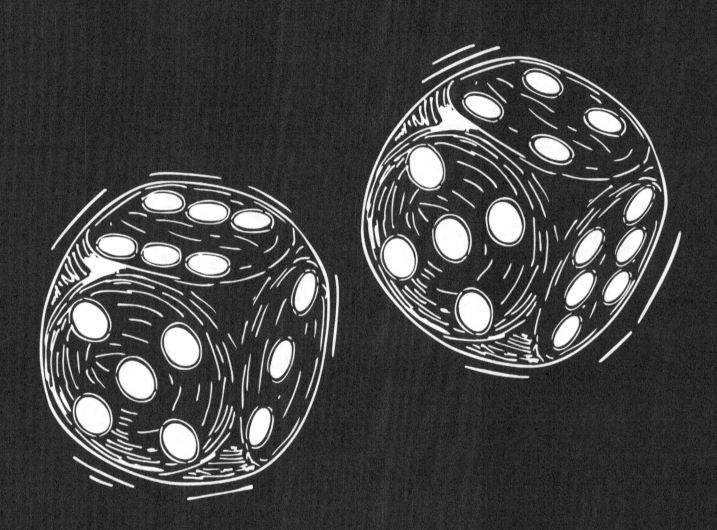

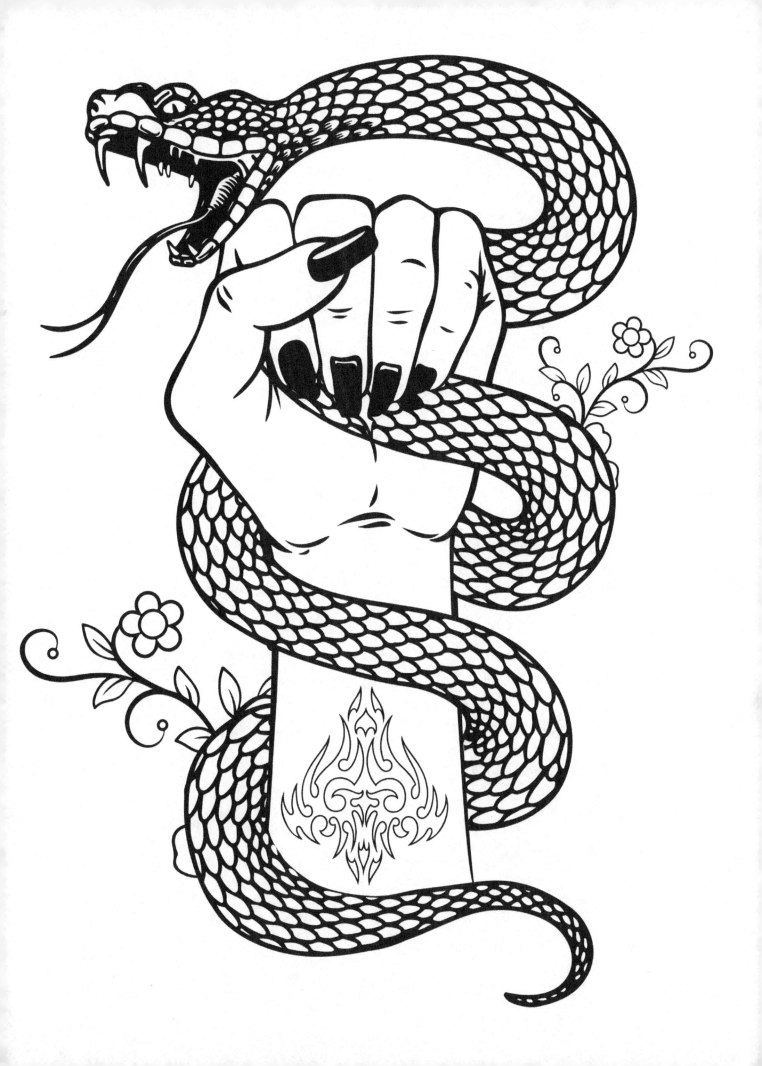

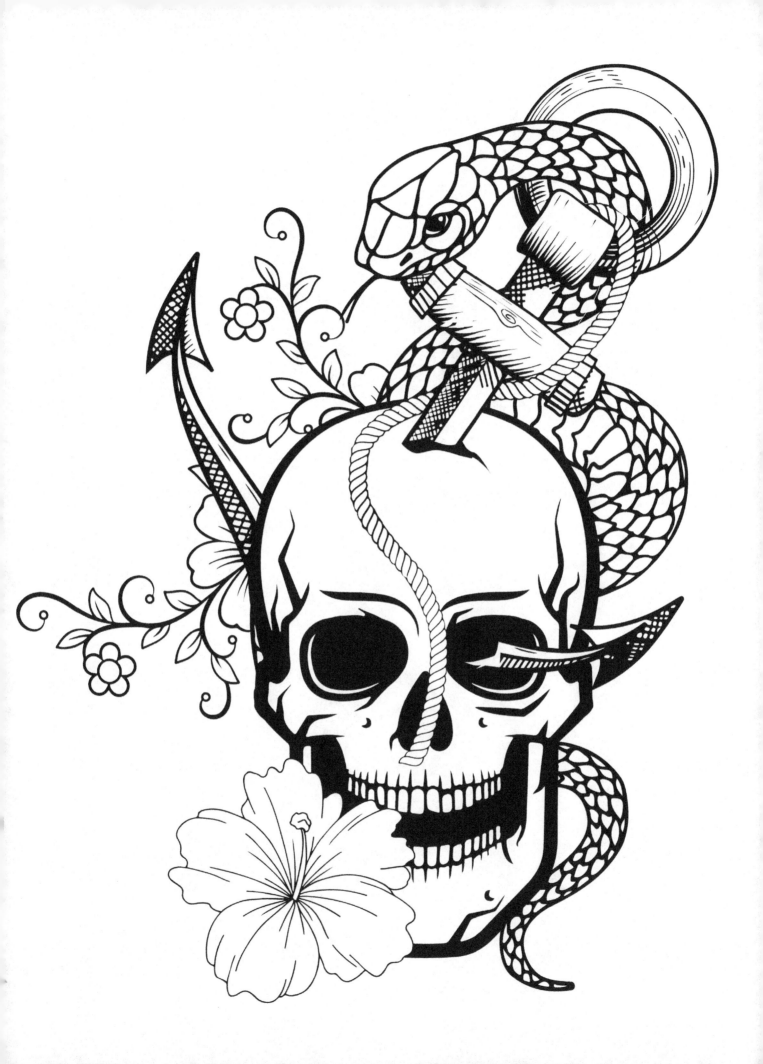

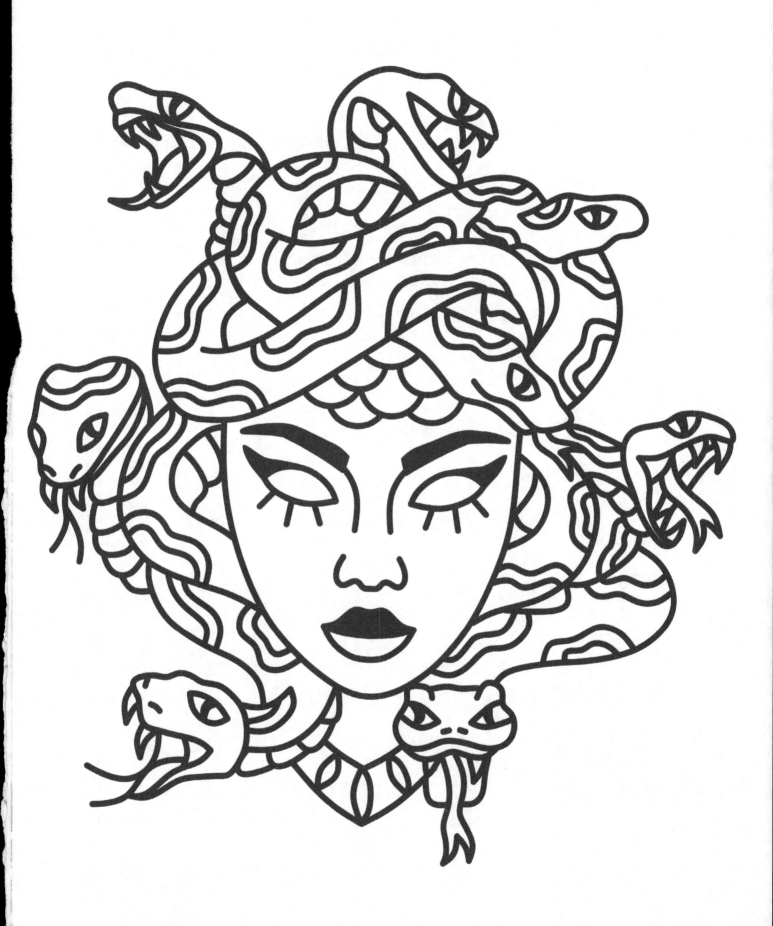

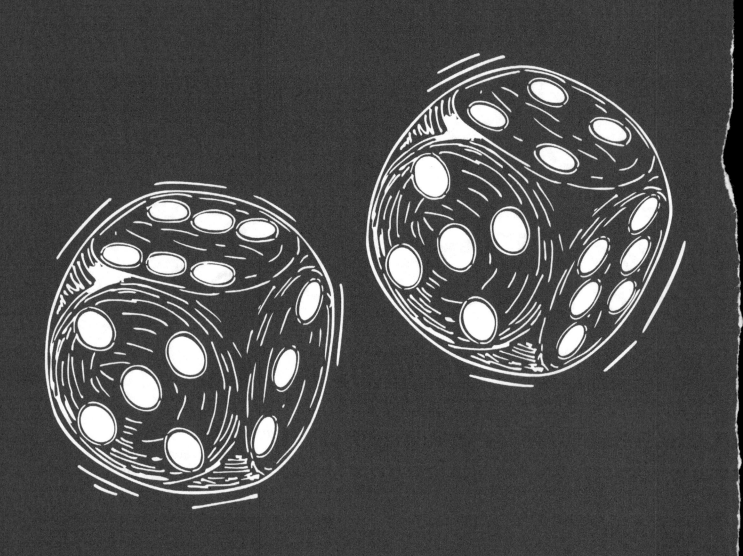

We create our books with love and great care.
Your feedback will help us improve this book and create new ones.
Your opinion matters a lot.
Support us and leave a review.

Thanks for your purchase

J. Fabian Rama and Rama Tattoo Coloring Press

Check out the coloring book family

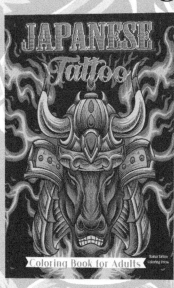

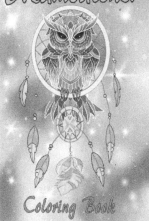

ISBN-13
979-8757673325

ISBN-13
979-8787219937

ISBN-13
979-8445190097

Made in the USA
Columbia, SC
12 July 2023

20356382R00057